The Doodle Diary

© Copyright 2023, 2016 Vickie VanHurley, Vickie VanHurley Art, LLC.
All Rights Reserved.

No part of this document may be reproduced or transmitted in any form or by any means, electronic, mechanical, photocopying, recording, or otherwise, without prior written consent of Vickie VanHurley Art, LLC.

Doodles courtesy of Adobe Stock Imagery and Freepik.

Vickie VanHurley
• Artist •
Vickie VanHurley Art, LLC

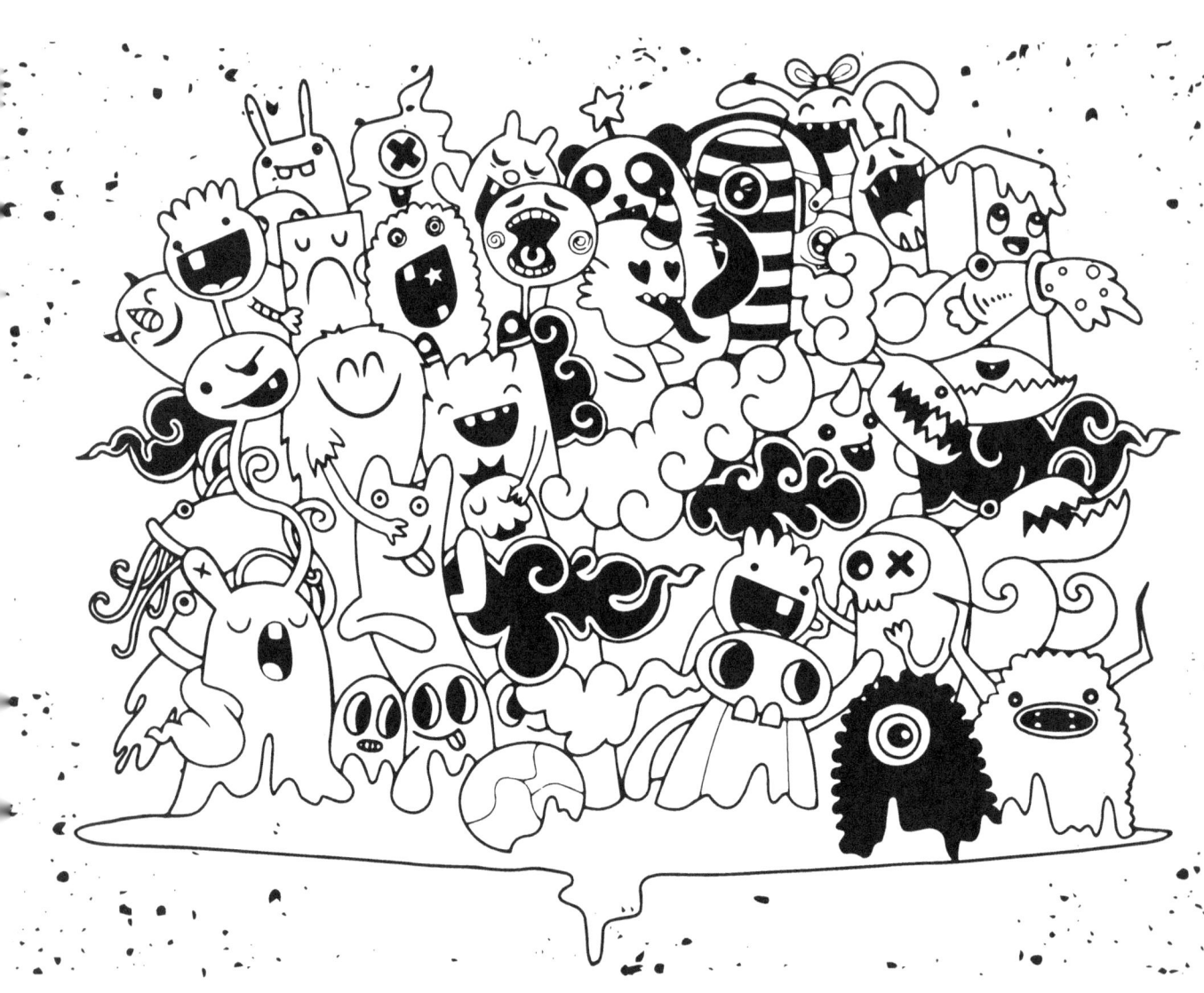

the doodle diary
Vickie L. VanHurley, Ph.D.

"Creativity is intelligence having fun."
~ Albert Einstein

instant doodle page

Trace the images below to instantly doodle.

instant doodle page
Trace the images below to instantly doodle.

doodle page

instant doodle page
Trace the images below to instantly doodle.

doodle page

doodle page

instant doodle page
Trace the images below to instantly doodle.

o o o o o o o o o o o o o o o o o

doodle page

Doodle, then write ideas, solutions on the lines below.

doodle page

instant doodle page
Trace the images below to instantly doodle.

doodle inspired ideas

Doodle, then write ideas, solutions on the lines below.

doodle page

doodle page

doodle page

instant doodle page
Trace the images below to instantly doodle.

doodle page

doodle page

finish the doodle!
Use your imagination to complete the doodle

finish the doodle!
Use your imagination to complete the doodle

doodle page

doodle page

doodle page

doodle page

instant doodle page

Trace the images below to instantly doodle.

○ ○ ○ ○ ○ ○ ○ ○ ○ ○ ○ ○ ○ ○ ○

doodle page

doodle page

doodle page

doodle page

doodle page

doodle page

doodle page

doodle page

doodle page

doodle page

instant doodle page

Trace the images below to instantly doodle.

doodle page

doodle page

doodle page

doodle page

doodle page

doodle page

doodle page

doodle page

doodle page

Doodle, then write ideas, solutions on the lines below.

doodle page

doodle page

instant doodle page

Trace the images below to instantly doodle.

doodle page

doodle page

doodle page

doodle inspired ideas
Doodle, then write ideas, solutions on the lines below.

doodle page

doodle page

doodle page

doodle page

instant doodle page
Trace the images below to instantly doodle.

doodle page

doodle page

doodle page

doodle page

doodle page

doodle page

doodle page

instant doodle page
Trace the images below to instantly doodle.

doodle page

doodle page

doodle page

doodle page

doodle page

doodle page

instant doodle page
Trace the images below to instantly doodle.

doodle page

doodle page

doodle page

doodle page

doodle page

doodle page

doodle page

doodle page

doodle page

doodle page

doodle page

doodle page

doodle page

instant doodle page

Trace the images below to instantly doodle.

doodle page

doodle page

doodle page

instant doodle page

Trace the images below to instantly doodle.

○ ○ ○ ○ ○ ○ ○ ○ ○ ○ ○ ○ ○ ○ ○

www.ingramcontent.com/pod-product-compliance
Lightning Source LLC
Chambersburg PA
CBHW081200180526
45170CB00006B/2167